FILL IN THE
BLANK

Created and designed by

ViiZ

Élodie Chaillous
& Vahram Muratyan

02-03 © jStock I 04-05 © frenta I 06-07 © Lance Bellers I 08-09 © Lucky Dragon I 10-11 © Dominique LUZY I 12-13 © Kristina Afanasyeva, © Kadmy I 14-15 © Galyna Andrushko I 16-17 © koya79, © Stefan Katzlinger I 18-19 © bloomua I 20-21 © Atlantis I 22-23 © trialhuni, © ExQuisine I 24-25 © Ingus Evertovskis I 26-27 © diversphoto89 I28-29 © DR I 30-31 © Stefan Katzlinger I 32-33 © dutourdumonde I 34-35 © Kayros Studio I 36-37 © Ljupco Smokovski I 38-39 © dred2010, © Gregor Buir I 40-41 © Eduardo Rivero I 42-43 © nfsphoto I 44-45 © Mike McDonald, © styleuneed I 46-47 © photka I 48-49 © picsfive I 50-51 © Sergej Khackimullin I 52-53 © trialhuni I 54-55 © RoJo Images I 56-57 © Mrkvica I 58-59 © dja65 I 60-61 © Yegor Korzh I 62-63 © Eric Isselée, © biglama I 64-65 © karandaev I 66-67 © RTimages I 68-69 © maksymowicz I 70-71 © gekaskr I 72-73 © hannamonika, © sborisov I 74-75 © Elena Schweitzer I 76-77 © robynmac I 78-79 © A-G-N-I, © Anyka I 80-81 © Stacy Barnett, © kameel I 82-83 © Big City Lights I © 84-85 picsfive I 86-87 © sumnersgraphicsinc, © Steve Cukrov I 88-89 © Artsem Martysiuk, © goce risteski, © jazavac, © brozova I 90-91 © Kitch Bain I 92-93 © Art Photo Picture I 94-95 © Yuri Arcurs I 96-97 © Eric Isselée I 98-99 Deklofenak I 100-101 © Maksim Toome I 102-103 © Vladimir Voronin, © Dmytro Sukharevskyy, © cantor pannatto, © maryo990, © Sergey, © Jiri Hera I 104-105 © gemenacom I 106-107 © arquiplay77 I 108-109 © 2d3dmolier, © Ruth Black, © Elenathewise I 110-111 © Graphissimo I 112-113 © Cobalt, © Faber Visum I 114-115 © Designer_Andrea I 116-117 © Bytedust, © Ariwasabi I 118-119 © U.P.images I 120-121 © Maxim Loskutnikov I 122-123 © Sergey Ilin, © valdis torms I 124-125 © innovari I 126-127 © Mykola Velychko I 128-129 © scol22, © Kelpfish I 130-131 © bernard favril I 132-133 © Ljupco Smokovski I 134-135 © Caroll I 136-137 © RTimages I 138-139 © Vidady I 140-141 © Inge Schepers I 142-143 © anankkml, © Smileus I 144-145 © DR I 146-147 © Africa Studio I 148-149 I148-149 © maeroris I 150-151 © FreshPaint I 152-153 © Ljupco Smokovski I 154-155 © klikk, © Ljupco Smokovski I 156-157 © Maksim Toome, © Anatoliy Meshkov, © Sergey Lavrentev I 158-159 © verte I 160-161 © DR I 162-163 © verte, © Dmitry Naumov I 164-165 © DR I 166-167 © fotomatrix I 168-169 © Africa Studio I 170-171 © Ilya Chalyuk I 172-173 © kmiragaya I 174-175 © tiero I 176-177 © robybret I 178-179 © olly, © DeoSum I 180-181 © verte I 182-183 © filograph I 184-185 © Jakub Jirsák, © Jose Manuel Gelpi, © nito I 186-187 © sellingpix I 188-189 © AlexandreNunes I 190-191 © Nicemonkey, © Maxim Pavlov, © Marc Dietrich I 192-193 © ketsur, © Kirill Kurashov I 194-195 © Neiromobile I 196-197 © He2, © Millisenta, © piai I 198-199 © NinaMalyna, © vj I 200-201 © Lambros Kazan, © rangizzz, © Jose Manuel Gelpi I 202-203 © Artyshot, © Matthew Benoit, © fotopak I 204-205 © wajan I 206-207 © Michael Rosskothen I

First published in the United States in 2012 by Quirk Productions, Inc.

Copyright © 2012 by ViiiZ

Library of Congress Cataloging in Publication Number: 2011946057

ISBN: 978-1-59474-580-5

Printed in China

Designed by ViiiZ and Doogie Horner
Production management by John J. McGurk

Quirk Books
215 Church St.
Philadelphia, PA 19106
www.quirkbooks.com
10 9 8 7 6 5 4 3 2 1

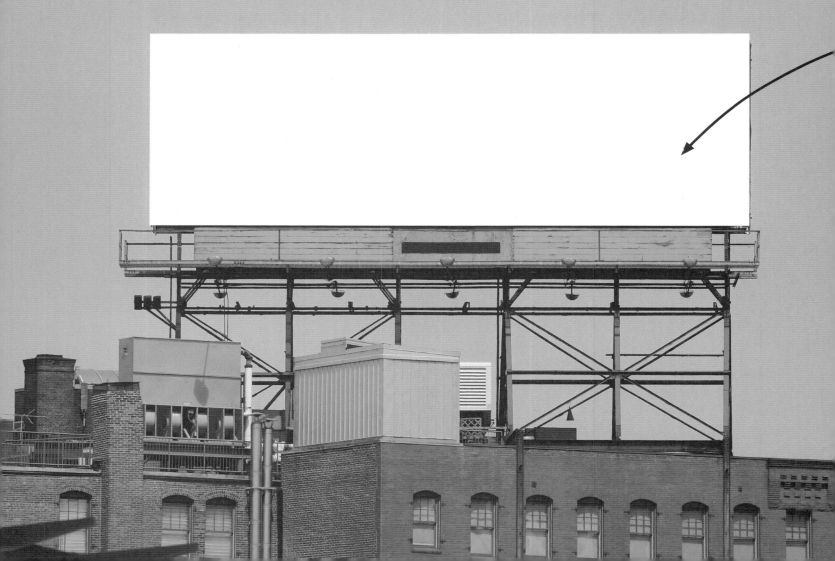

Check if you agree

☐ you enjoy drawing
☐ you are creative
☐ you know nothing about drawing
☐ you wish you could get some help
☐ you are good at what you do
☐ you want to be famous
☐ you are what you read
☐ you pretend to be a ..
☐ you want to be a king, an architect, a sculptor, or a designer
☐ you are bored easily and you want to have fun
☐ you think you are way underrated
☐ you need a real goal in life
☐ you could be the next Picasso, Karl Lagerfeld, or
☐ you know the basics but you want to learn more
☐ you want to improve your skills
☐ you suck, but this book is the perfect gift for
☐ you want to do more than just doodling
☐ you wanted an art degree but you are color-blind
☐ you want to change your career
☐ you dream of an exhibit with your name on the wall

FILL IN THE
BLANK

A creative activity book to go with the flow,
where cars, cats, and castles will look the way you want,
you can draw your ideal house, your perfectly designed ,
the yummiest ice cream, or a new race in the animal kingdom.

Get the book, get a nice pen, get a
Enjoy.

YOU ARE A
CAVEPERSON

what message would you leave behind?

YOU ARE A
CAVEPERSON

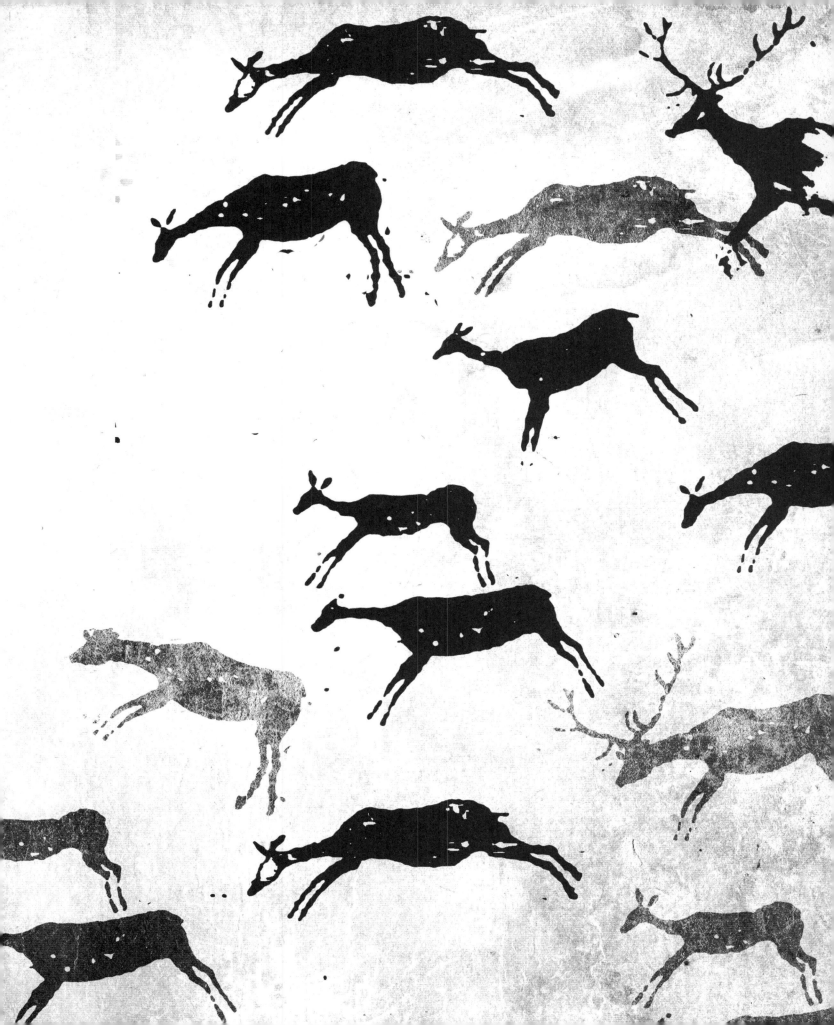

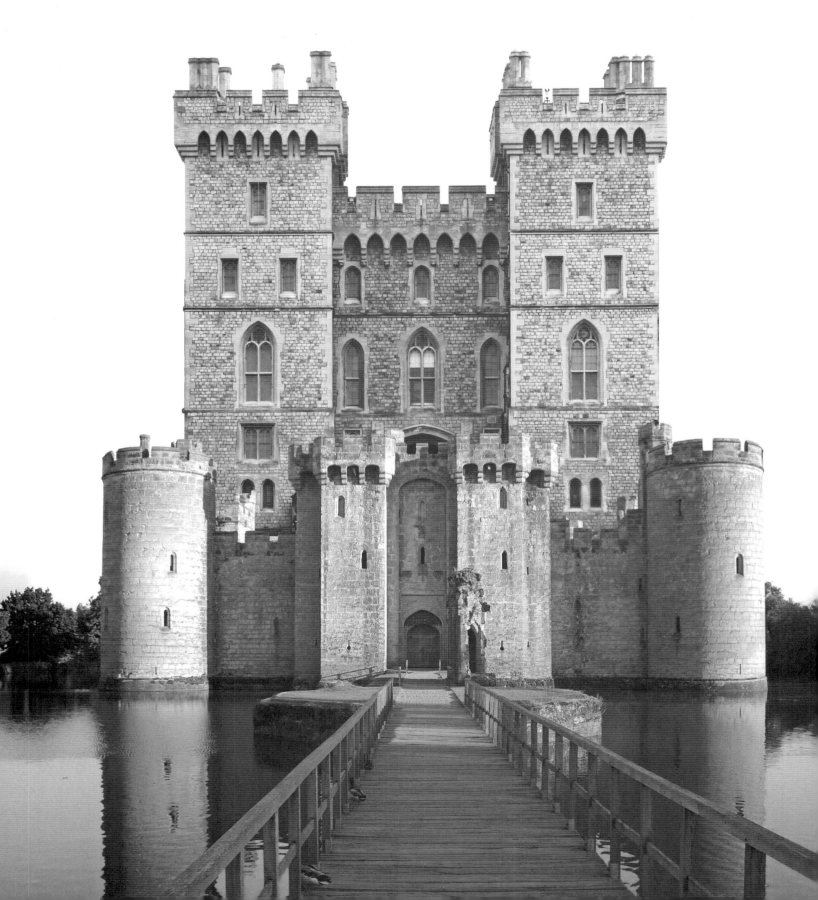

YOU ARE AN
ENGINEER

build your bridge

YOU ARE A
CHEF

bon appétit!

YOU ARE A
MAHARAJAH

what would you have done instead?

YOU ARE A
WORLD TRAVELER

bring back souvenirs

YOU ARE AN
APP DESIGNER

what will fil your screen?

YOU ARE A
BUILDER
what would you have created?

YOU ARE AN
ARCHITECT

build your dream house

YOU ARE A
LABEL DESIGNER

what sodas will you invent?

YOU ARE A
SIGN MAKER

LOST

WORK FROM HOME

YOU ARE A
SCULPTOR

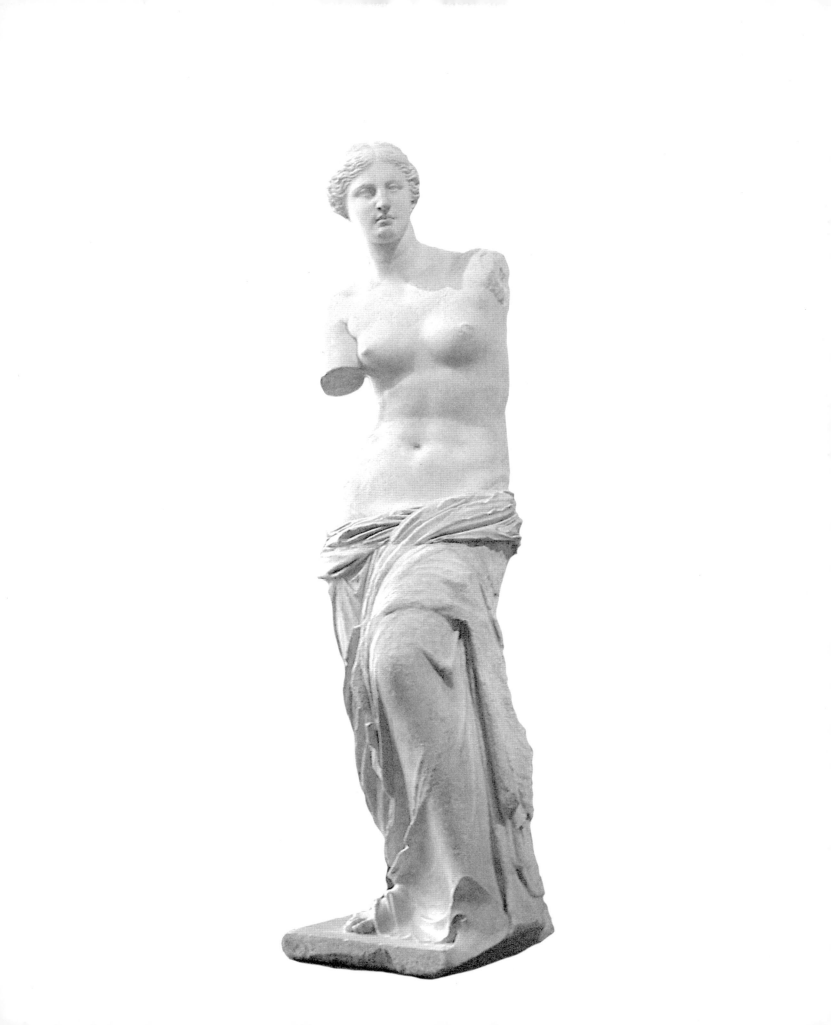

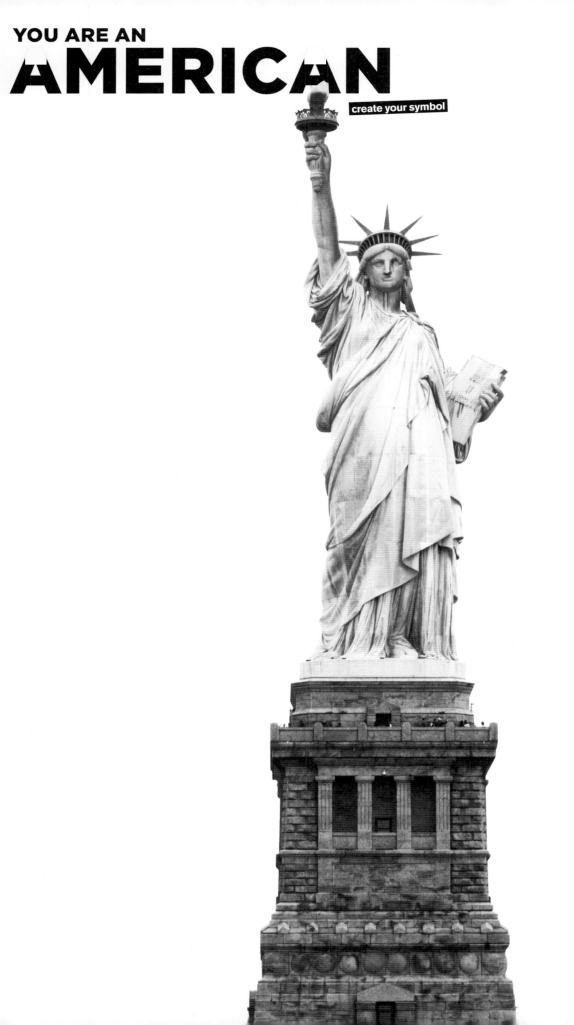

YOU ARE AN
AMERICAN
create your symbol

YOU ARE A
STREET ARTIST

and you won't be arrested!

YOU ARE A
PET LOVER

what creatures will you keep away from the cat?

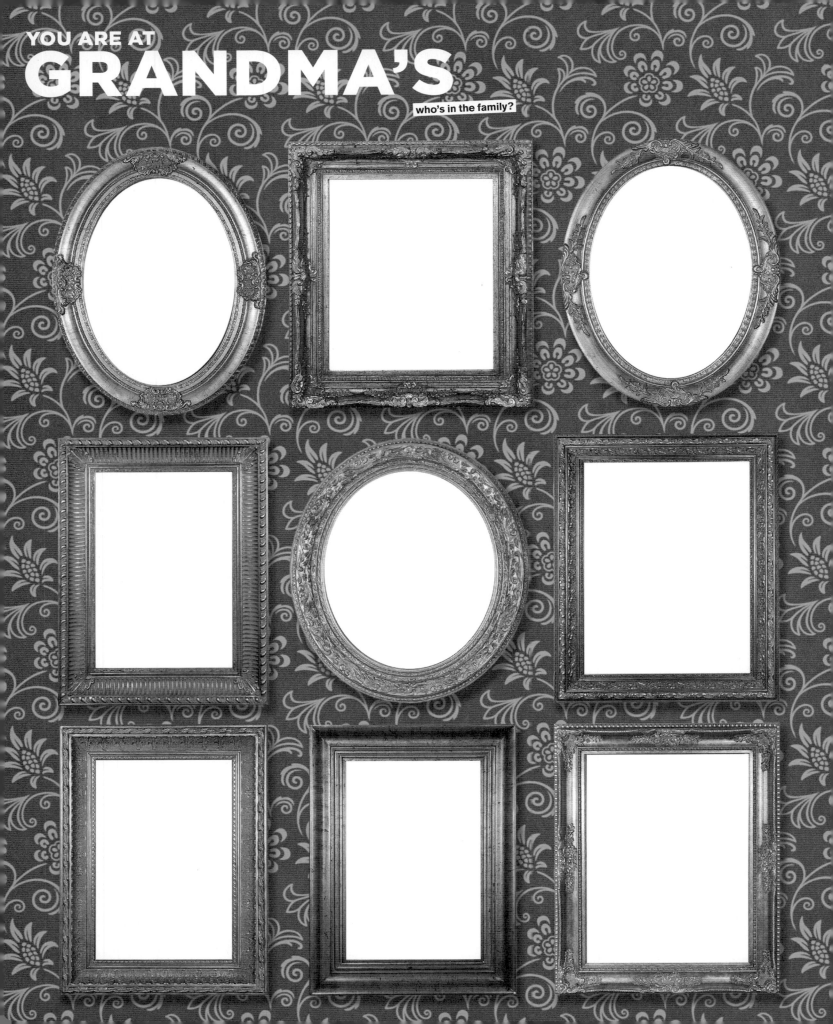

YOU ARE A
DOG SITTER

who will come for dinner?

YOU ARE A
BILLBOARD DESIGNER

what are you selling?

YOU ARE A
BARISTA
design your cups

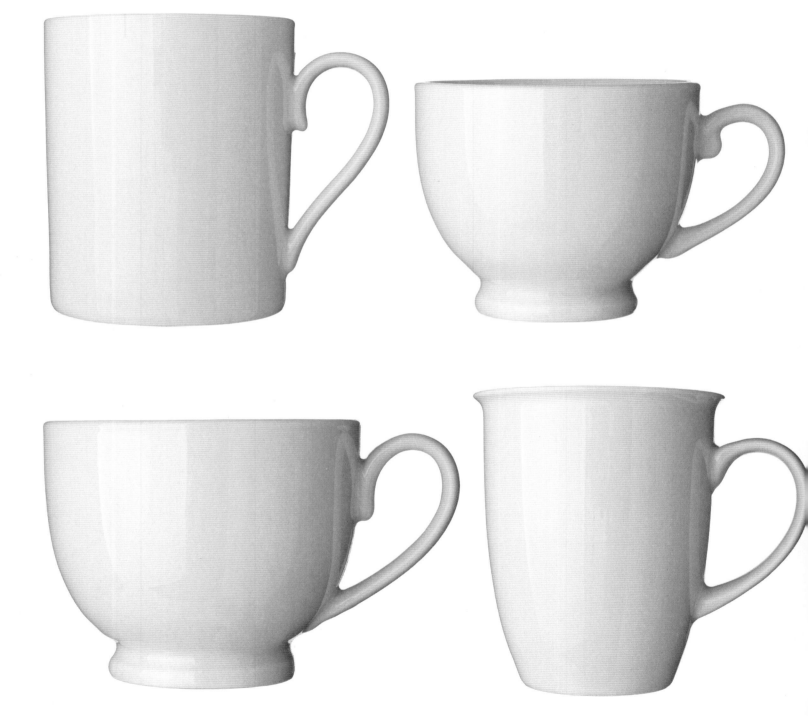

YOU ARE AN
ARTIST

create your biggest work yet

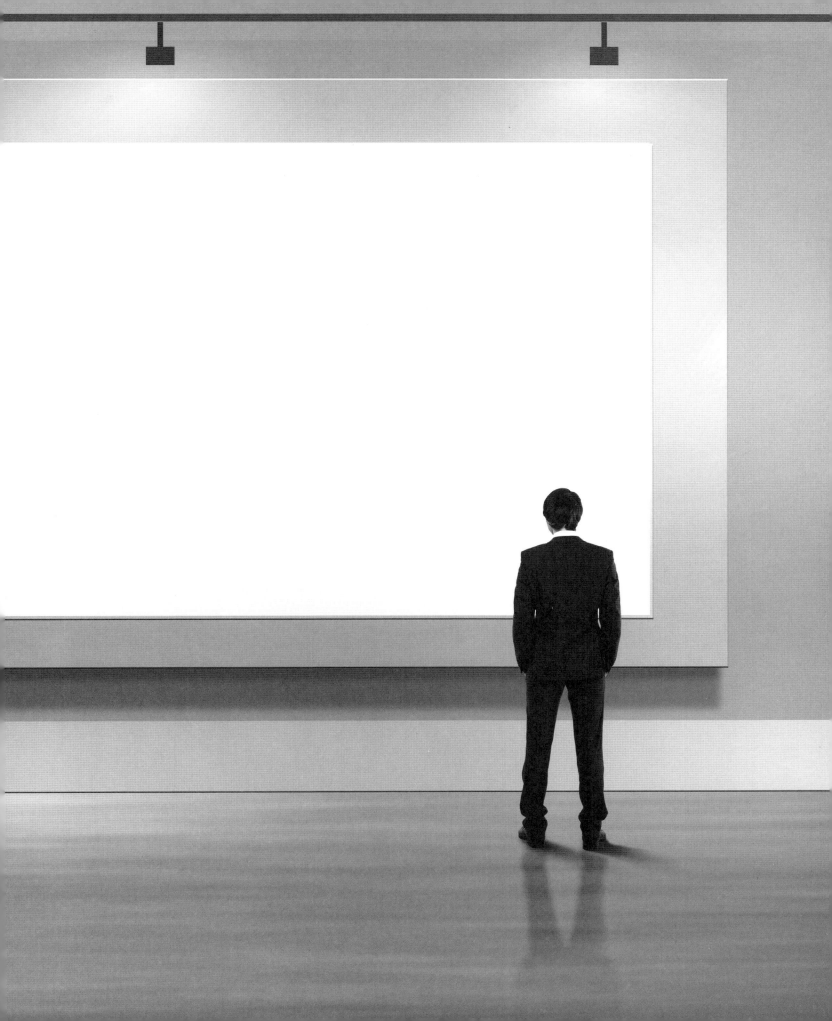

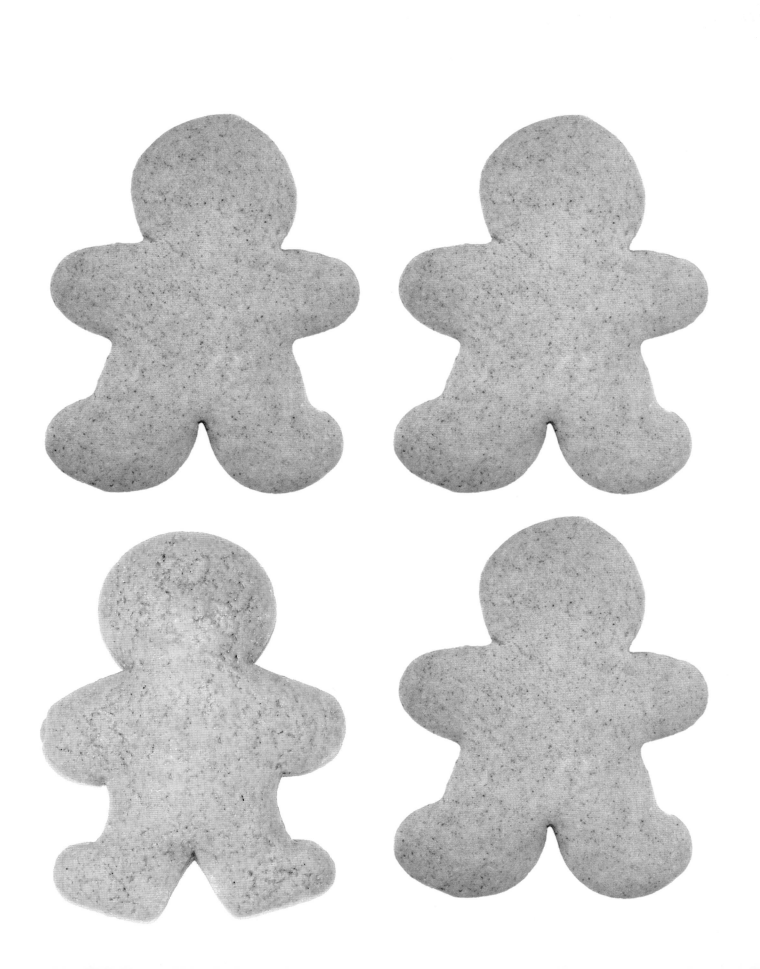

YOU ARE IN A
FAIRYTALE

once upon a time

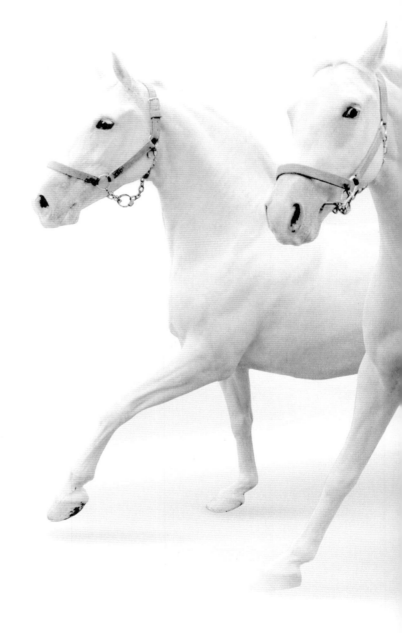

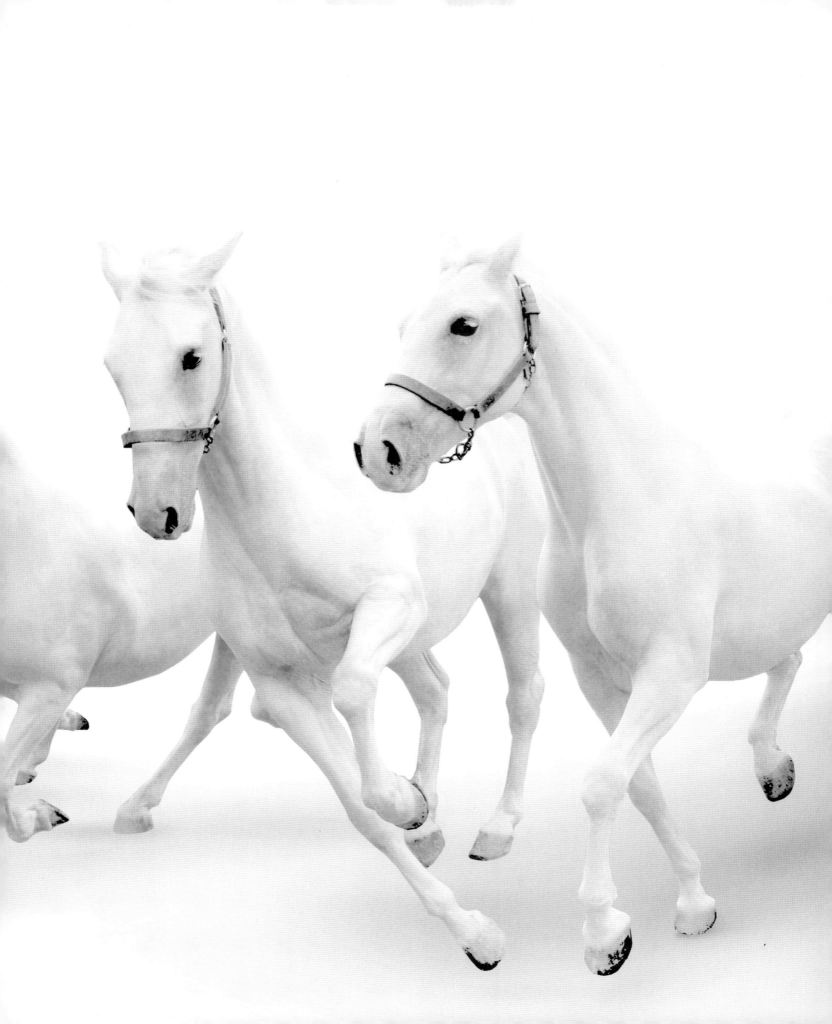

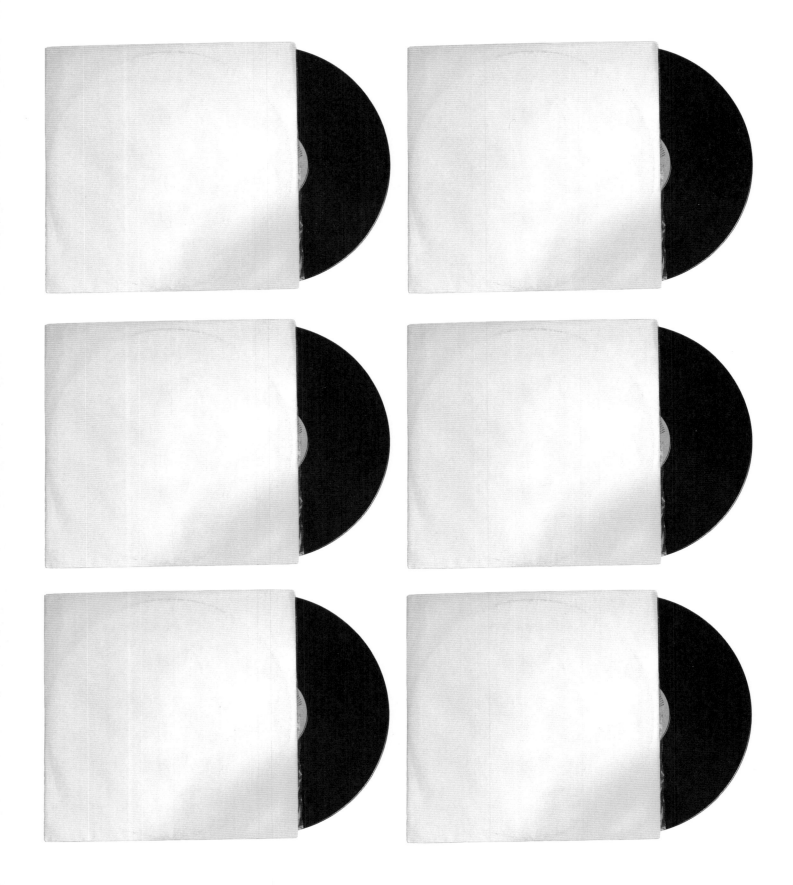

YOU ARE A
GENIUS

these ideas will make you rich

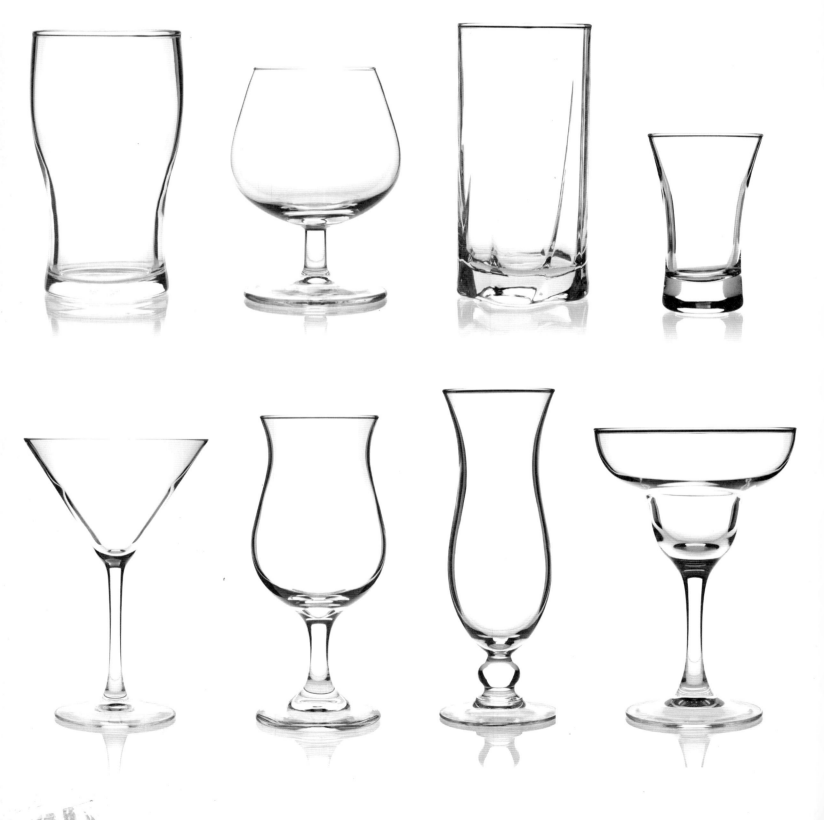

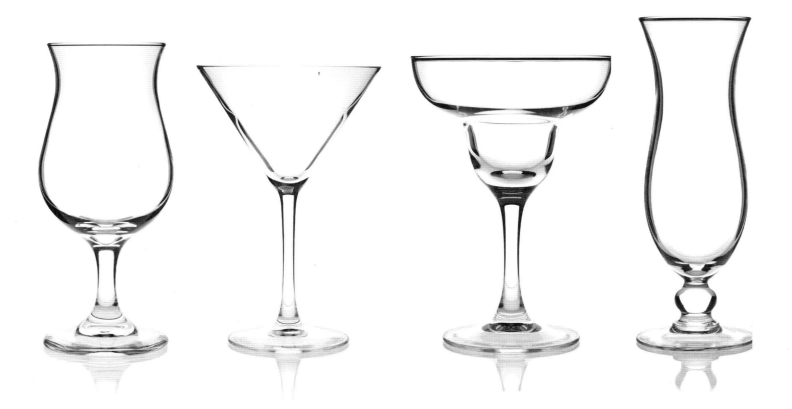

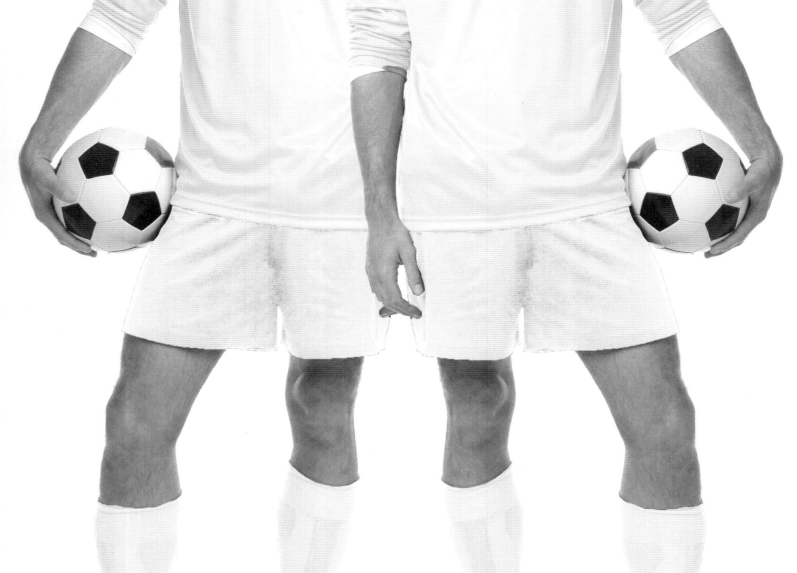

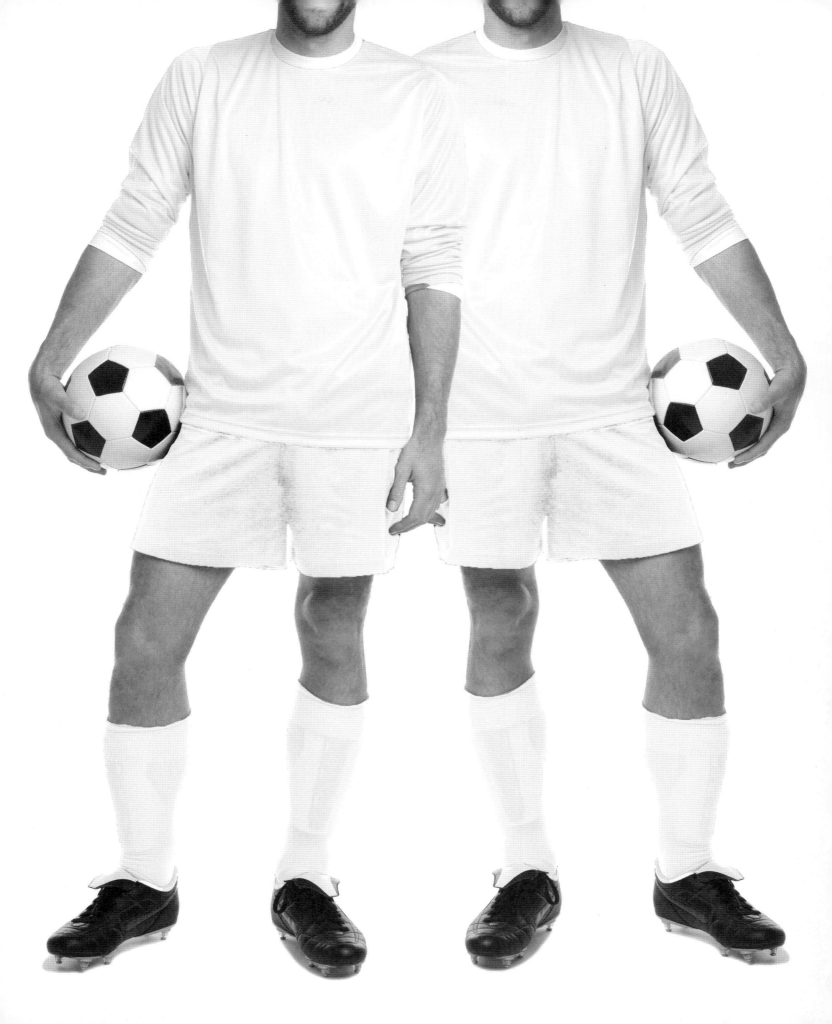

YOU ARE ON
ROUTE 66

design the billboards that will bring folks in

YOU ARE A
TATTOO ARTIST

make your mark

YOU ARE A
STUDENT

YOU ARE SO
CLUMSY

who signed your cast?

YOU ARE A
DIVA
what's your look?

YOU ARE A
CONTROL-FREAK

write crazy memos

YOU ARE A CRAFT BREWER

what did you make?

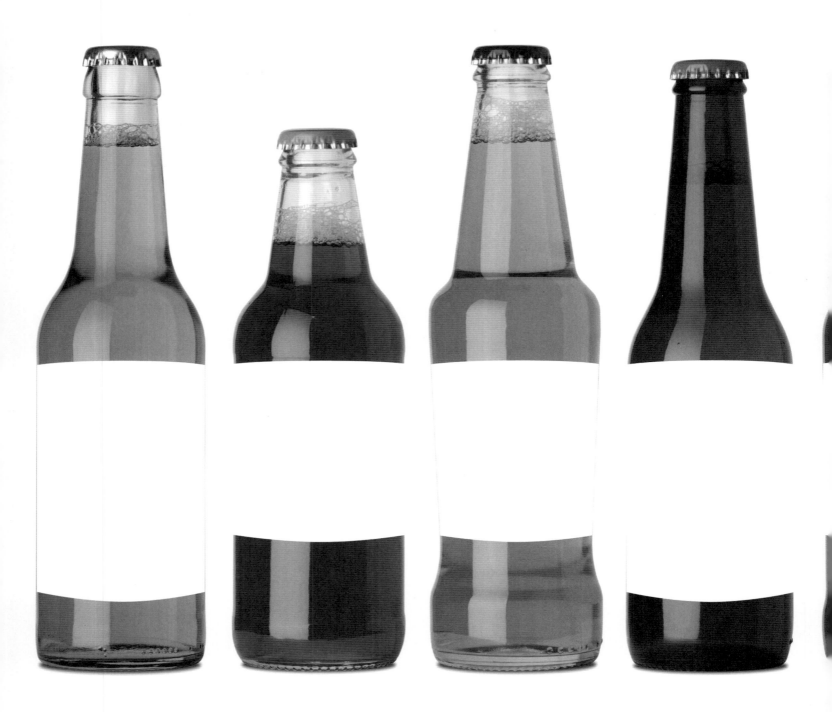

YOU ARE A ROLLER COASTER
DESIGNER

create the greatest scream machine

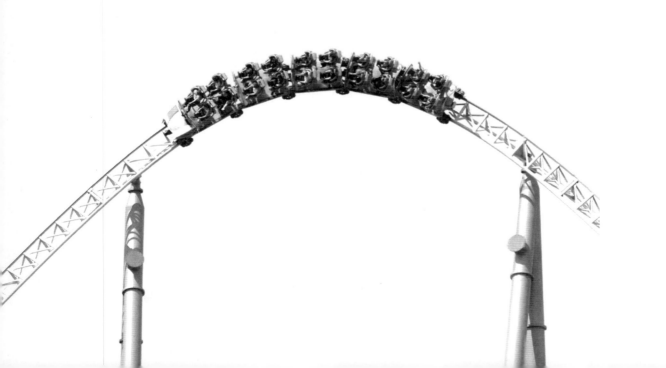

YOU ARE
ADRIFT AT SEA

what's on land?

YOU ARE A
SHOE ADDICT

design the shoes that fit

YOU ARE A
DECORATOR

apply your wallpaper

DECORATOR

YOU ARE A
SHOPPING ADDICT

YOU ARE
THE VOICE

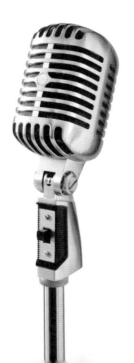

YOU HAVE A
DATE

what will you bring?

YOU ARE A
JOKER
what's in the box?

YOU ARE AN
ALIEN

what are you studying?

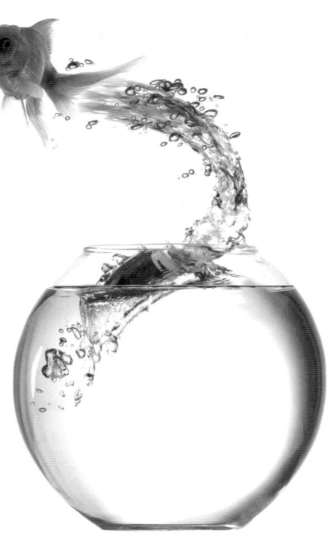

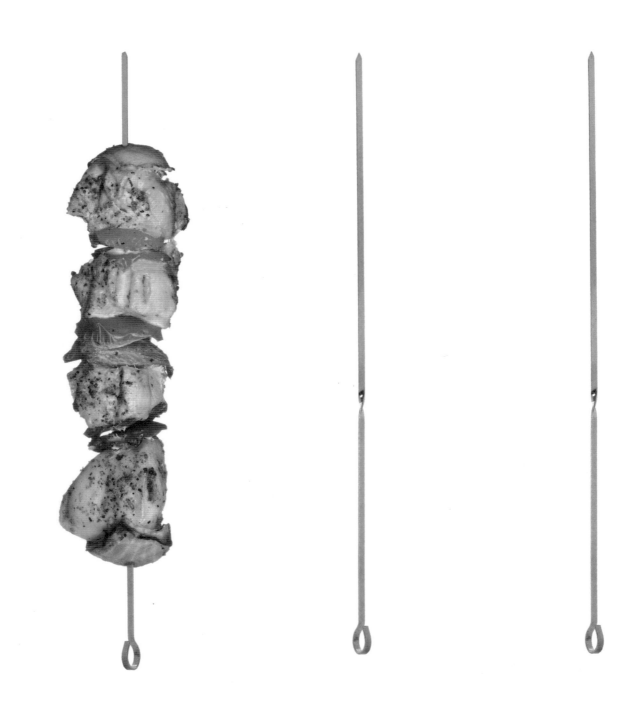

YOU ARE A
SURVIVOR
jungle barbecue time

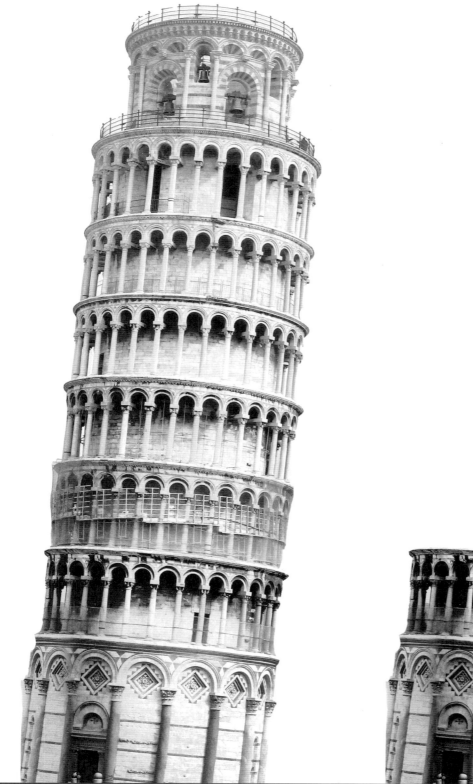

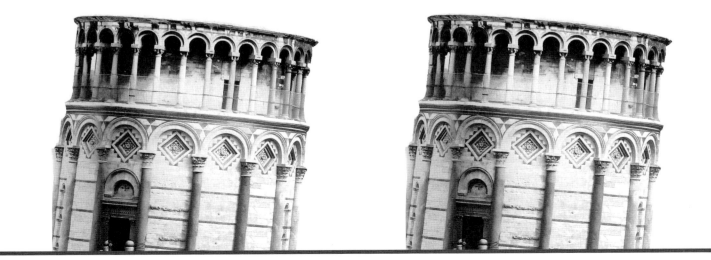

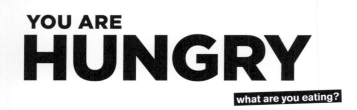

YOU ARE
HUNGRY

what are you eating?

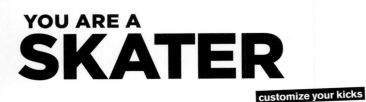

YOU ARE A
SKATER

customize your kicks

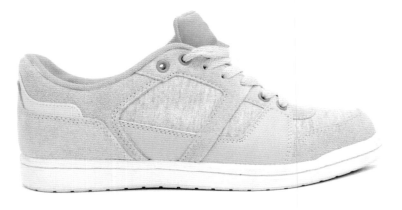

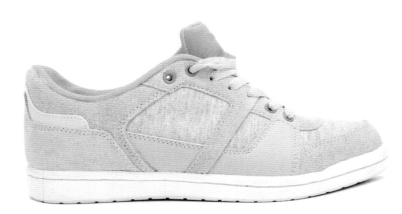

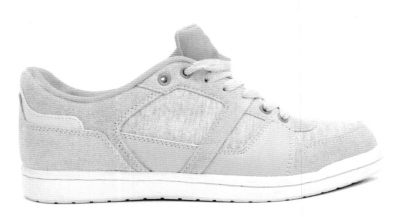

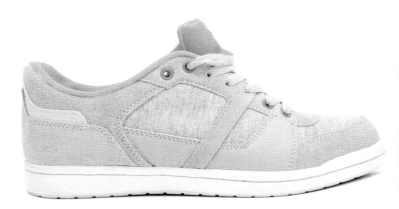

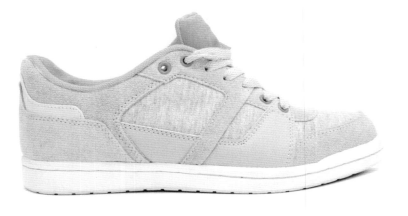

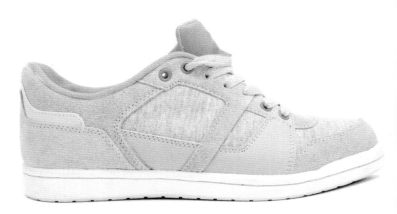

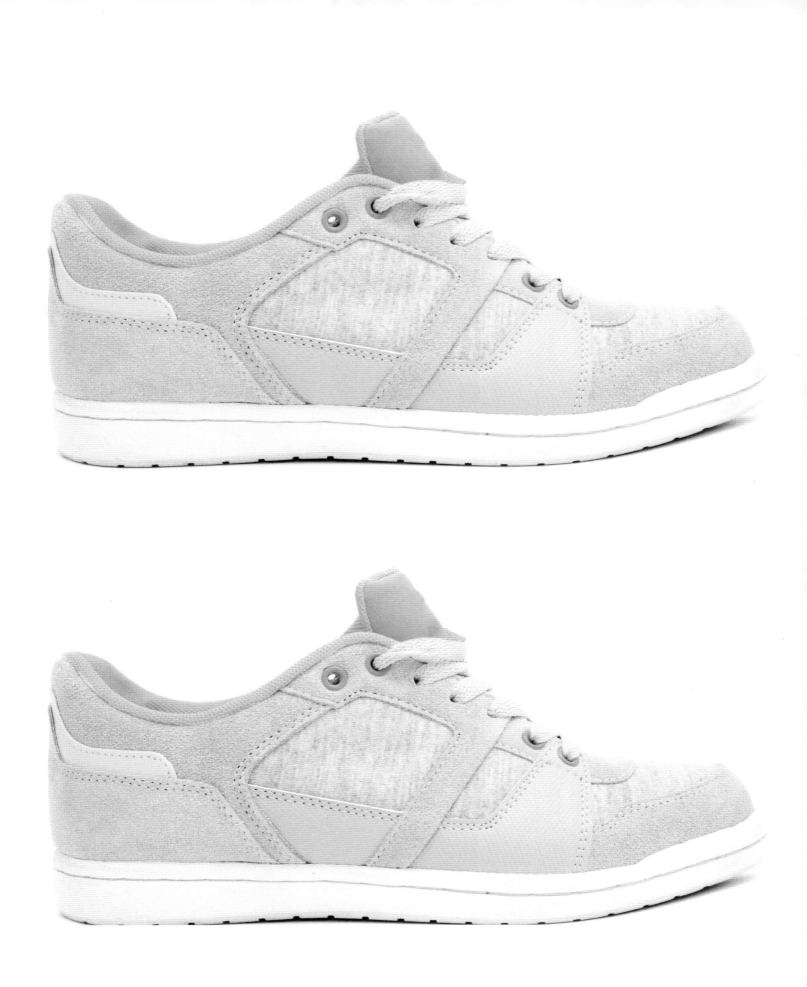

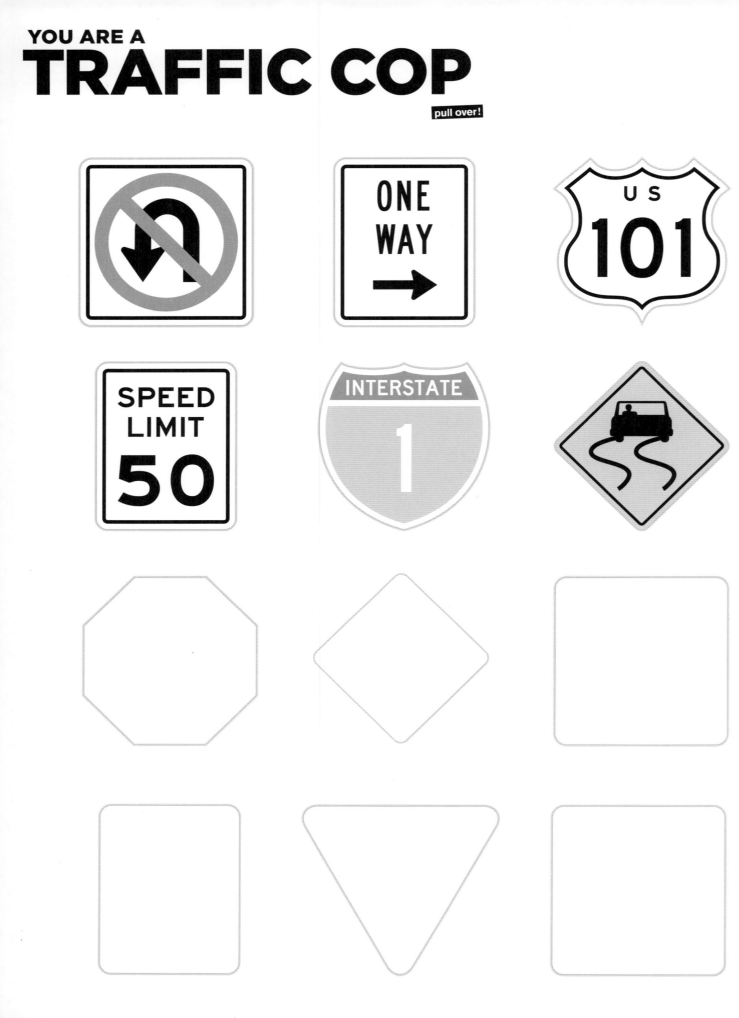

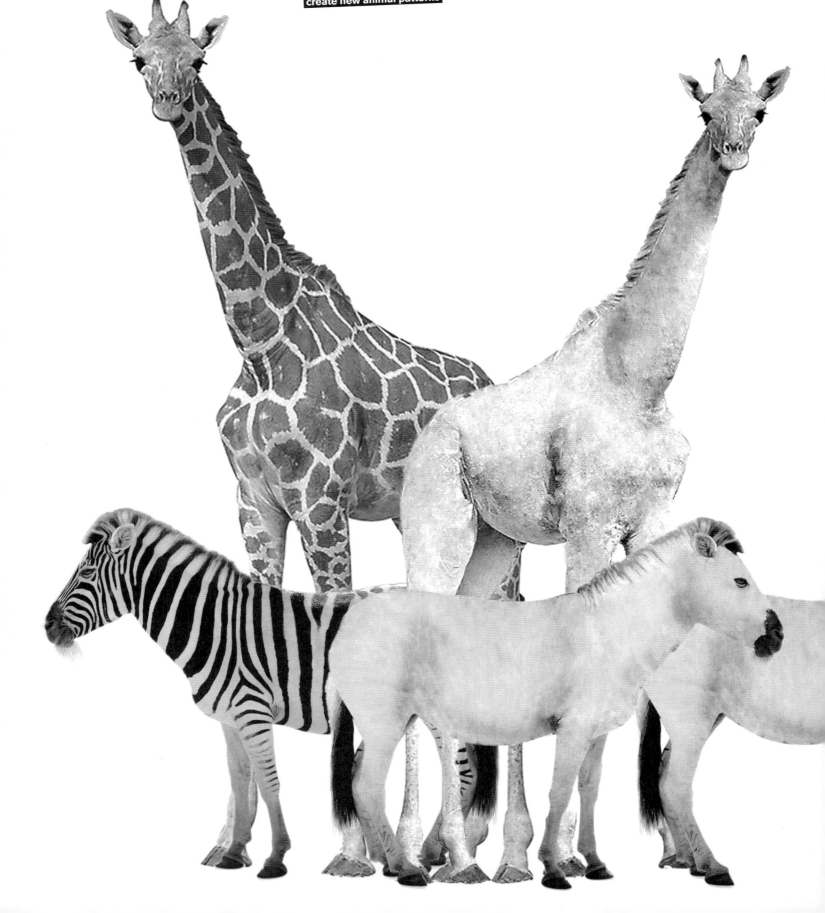

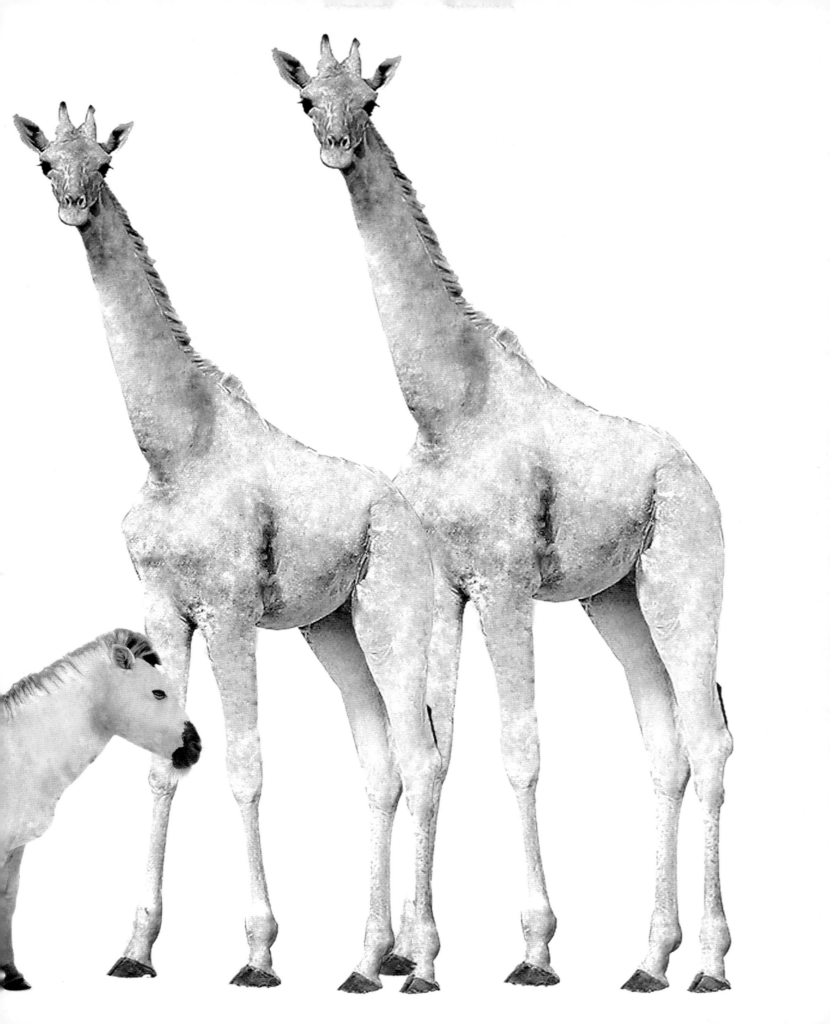

YOU ARE AN
ICE CREAM MAKER

present your yummy creations

YOU ARE A
BUSINESSPERSON

introduce yourself

YOU ARE A

POSTERMAKER

it's time to promote yourself

YOU ARE A
BILLIONAIRE

alll you can dream of is…

YOU ARE AN
ILLUSIONIST

abracadabra

YOU ARE A
CUSTOMIZER

YOU ARE AN
AUTOBIOGRAPHER

YOU ARE A
GUITAR MAKER

YOU ARE A
SNACK ADDICT

design your favorite junk

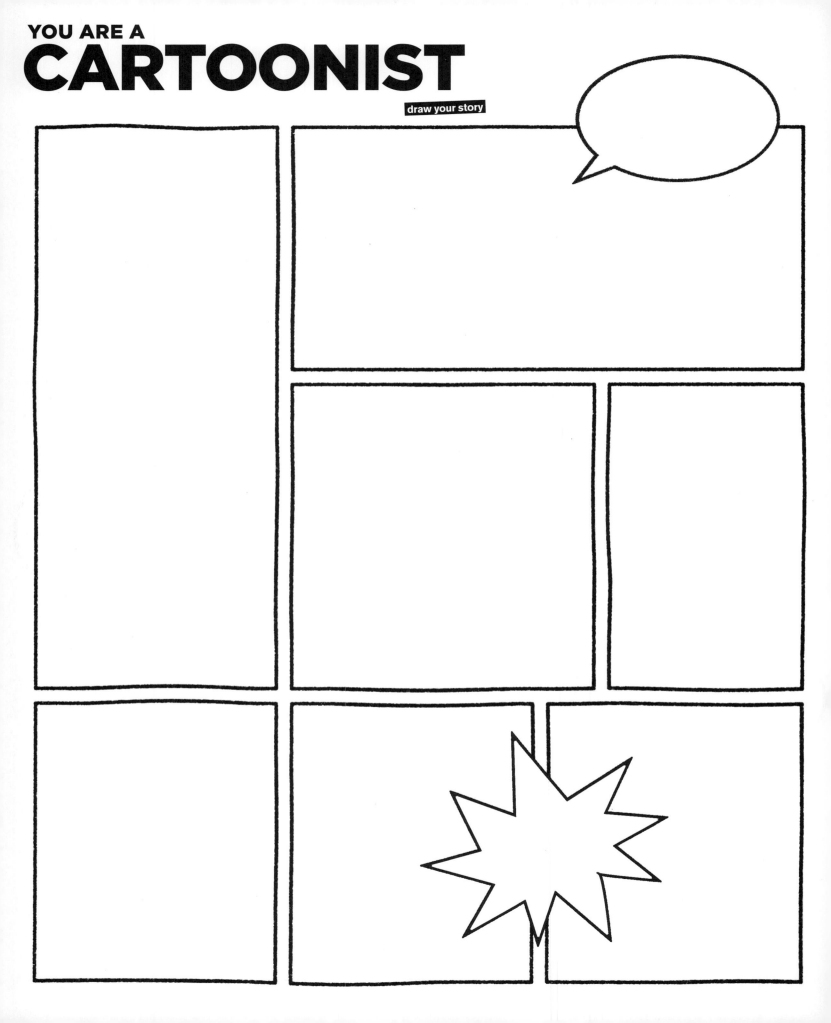

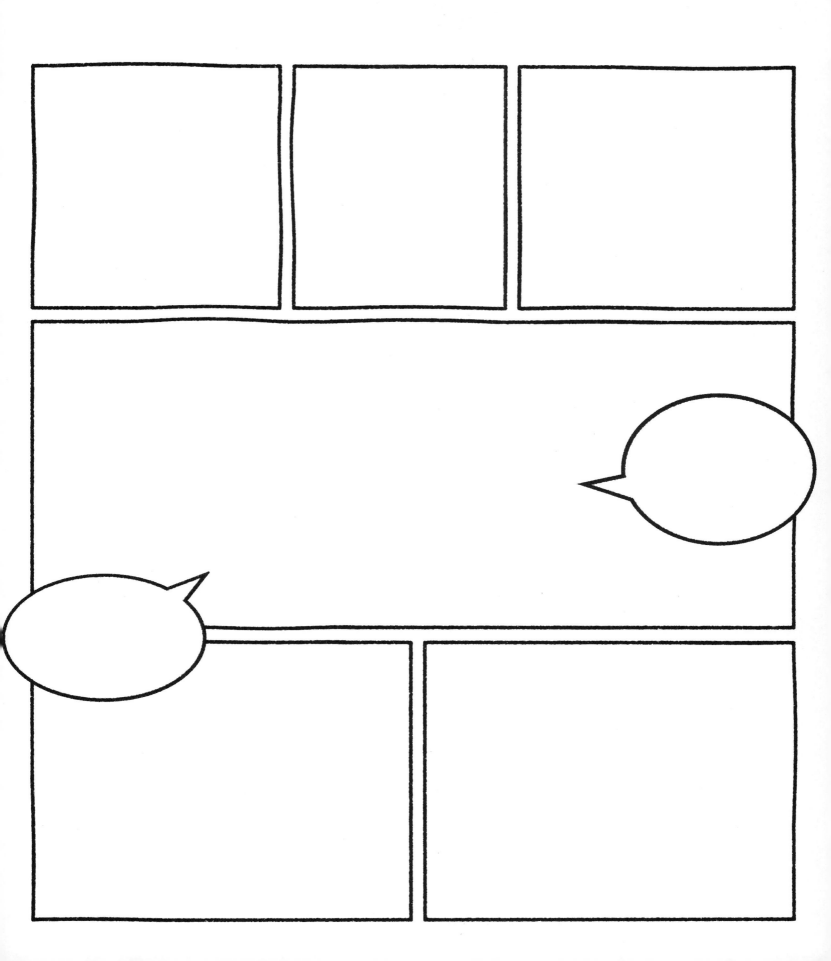

YOU ARE A VOODOO PRACTITIONER

ex, boss, it's time for revenge

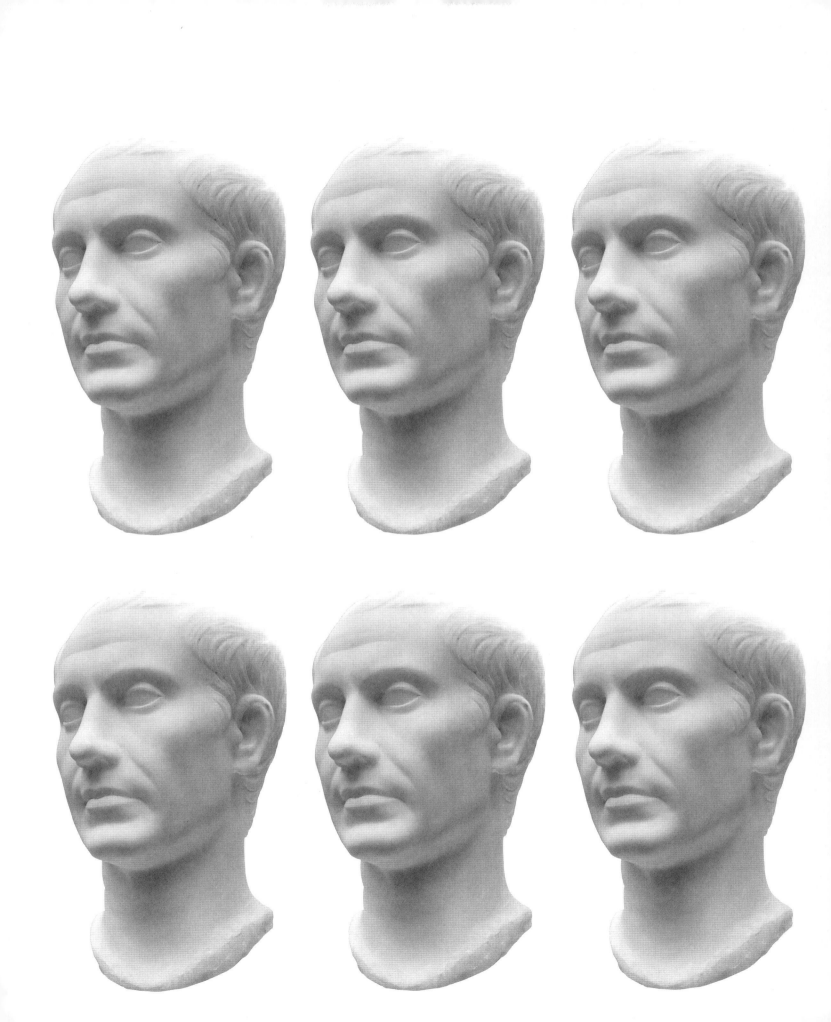

YOU ARE
NOSTALGIC

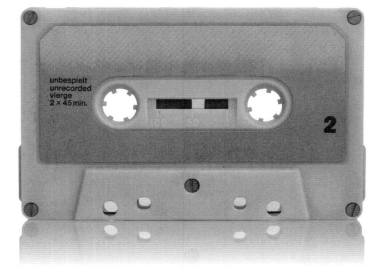

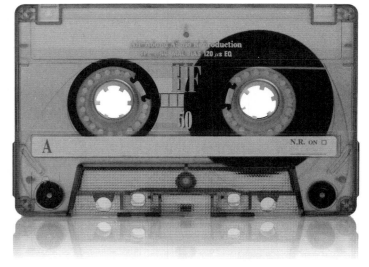

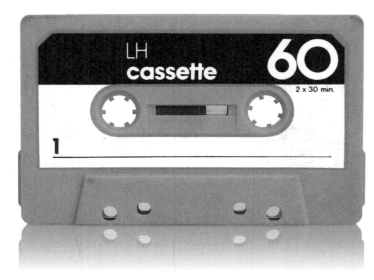

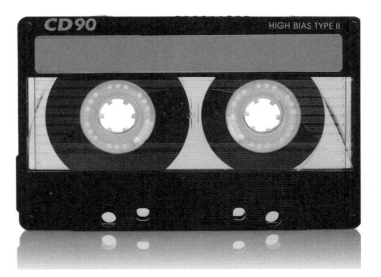

ASTRONOMER

connect the stars and create new constellations

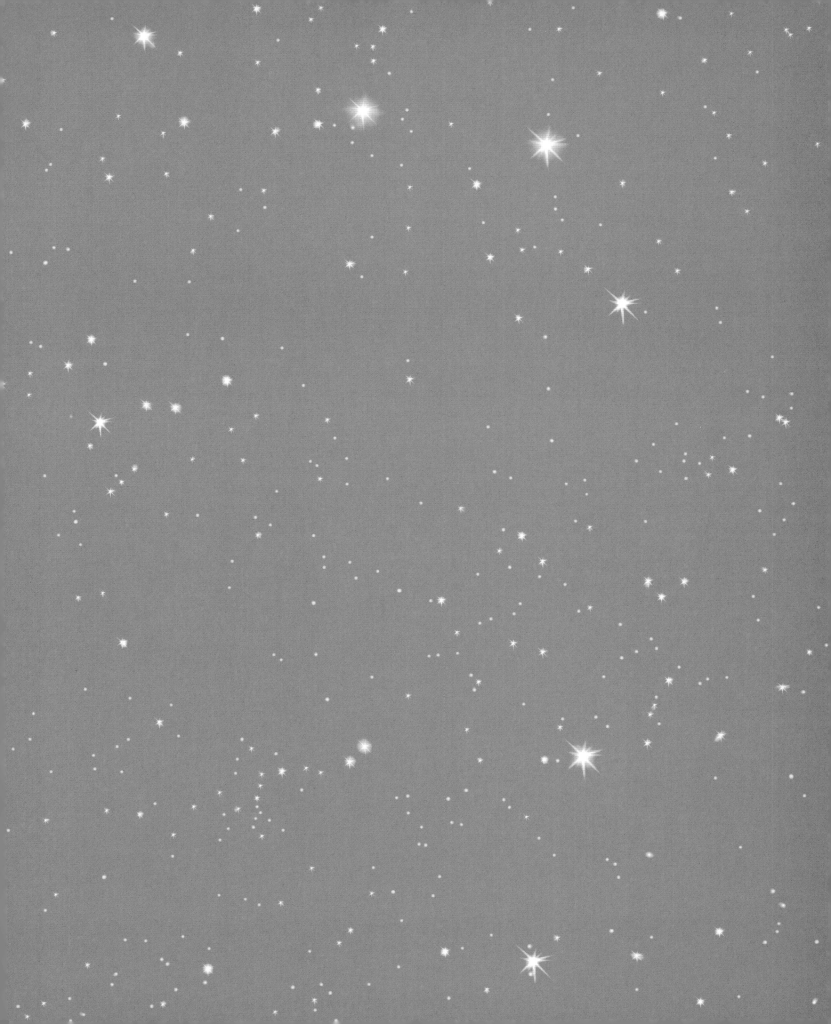

YOU ARE A
BELIEVER

aliens are invading

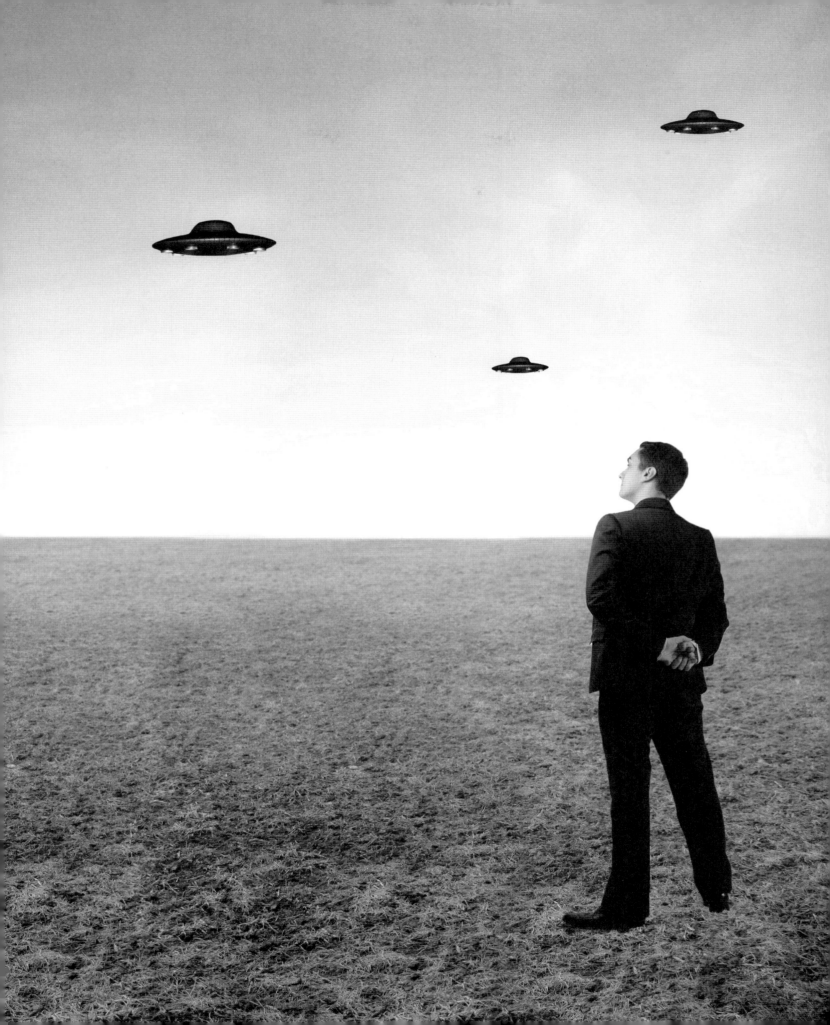

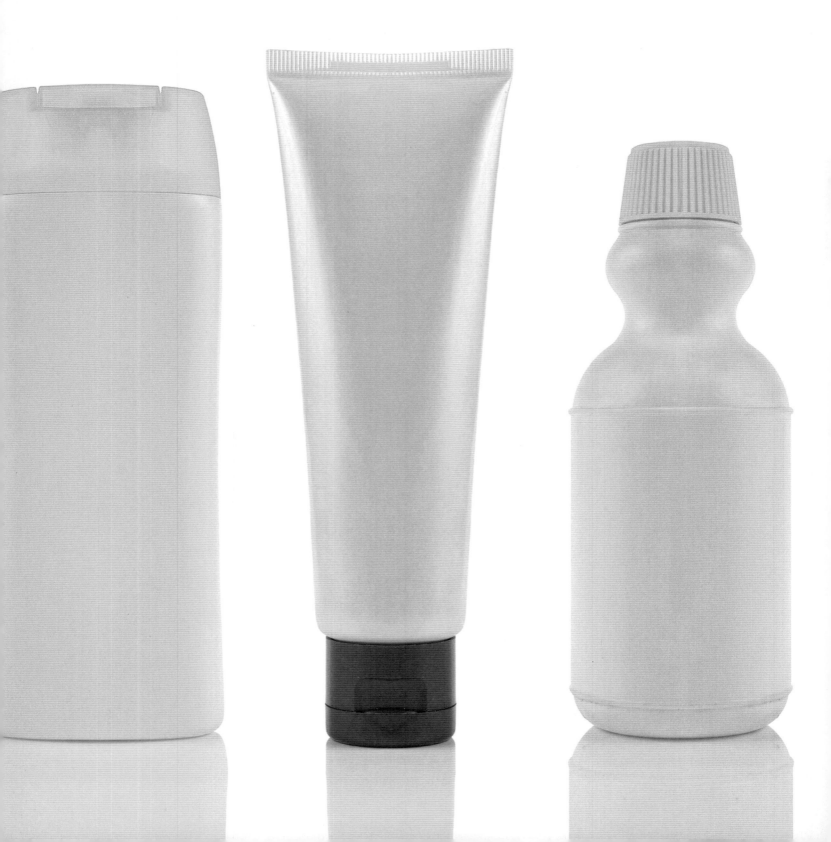

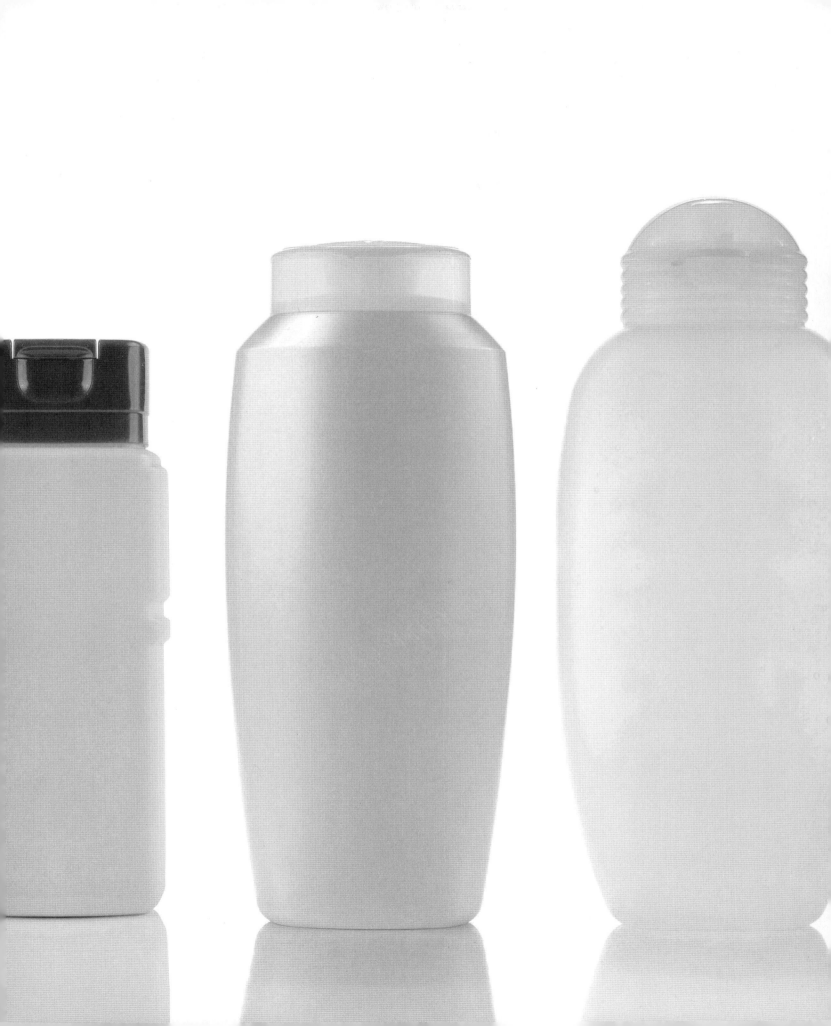

YOU ARE
SINGING IN THE RAIN

color your umbrella sea

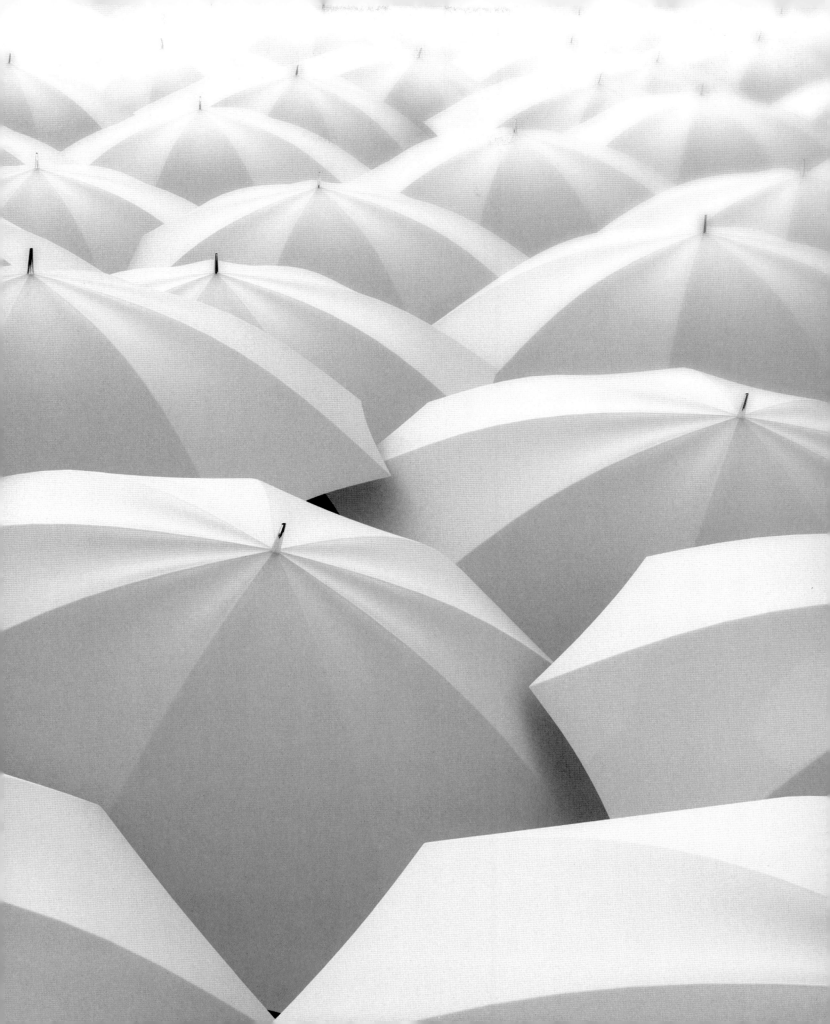

YOU ARE GETTING
MARRIED

design your wedding cake

YOU ARE A CITY
BUILDER

create the city at the end of the road

I WILL NOT

I WILL NOT

I WILL NOT

I WILL NOT

I WILL NOT

I WILL NOT

I WILL NOT

I WILL NOT

I WILL NOT

I WILL NOT

I WILL NOT

I WILL NOT

I WILL NOT

I WILL NOT

I WILL NOT

I WILL NOT

I WILL NOT

I WILL NOT

I WILL NOT

I WILL NOT

I WILL NOT

I WILL NOT

I WILL NOT

I WILL NOT

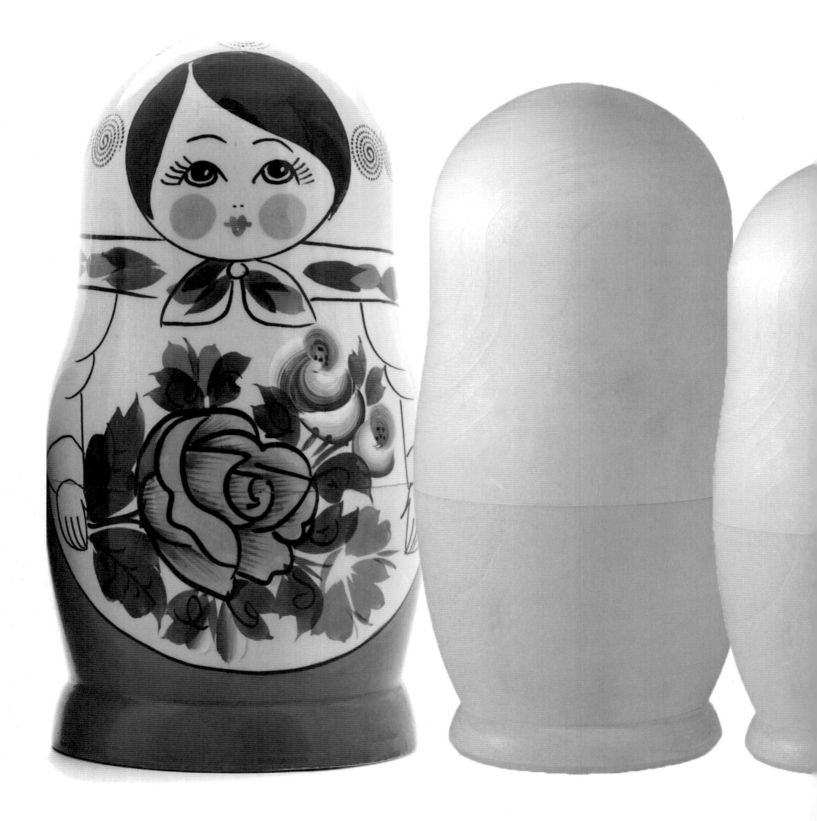

YOU ARE
THIRSTY
what do you want to drink ?

YOU ARE A
SPORTS FAN

what are your favorite teams?

YOU FOUND YOUR OLD
VIDEO COLLECTION

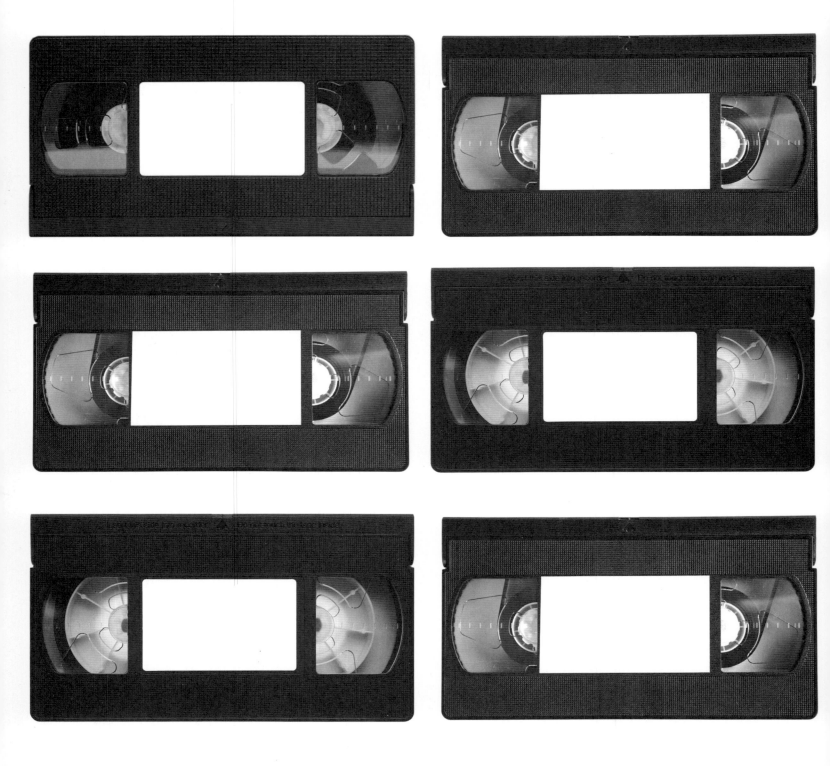

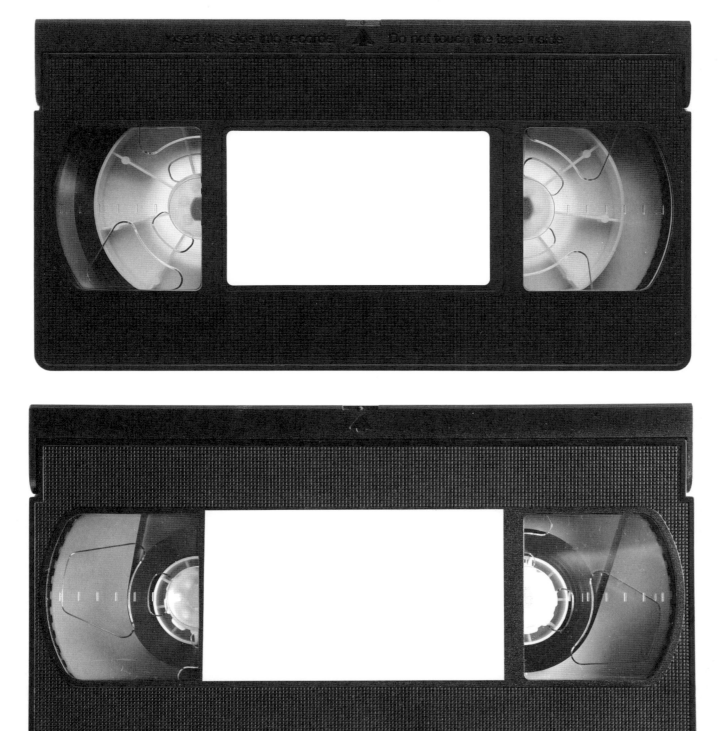

YOU ARE A FORTUNE
COOKIE BAKER

behold your future!

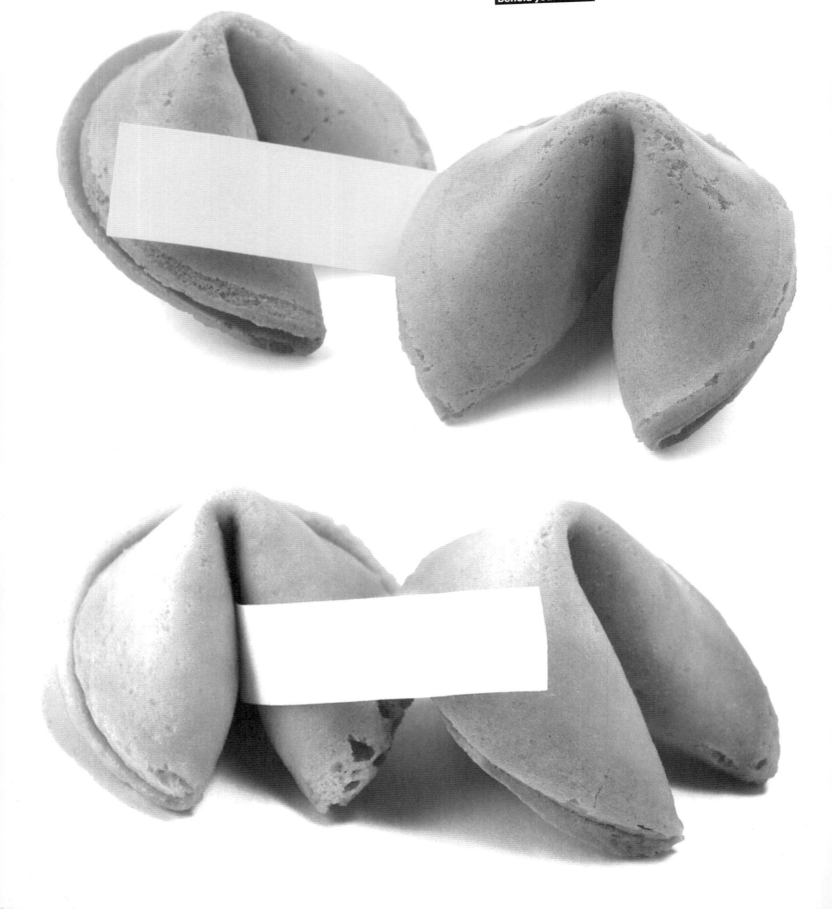

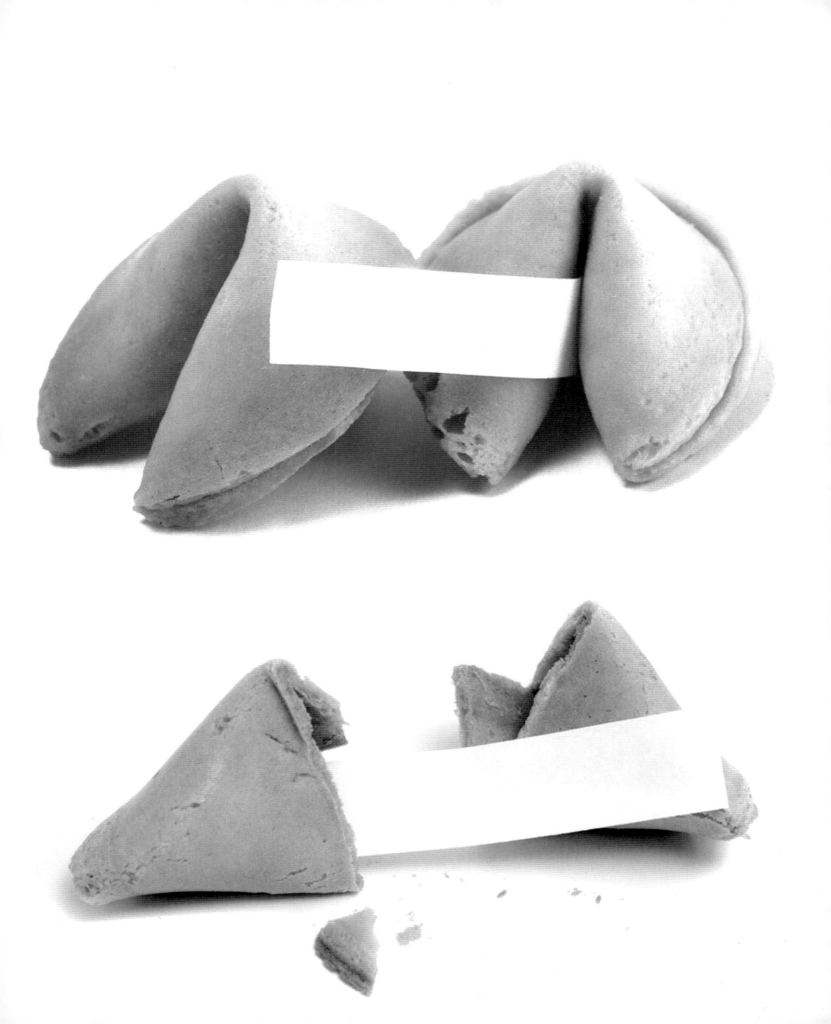

SCUBA DIVER

what lurks beneath?

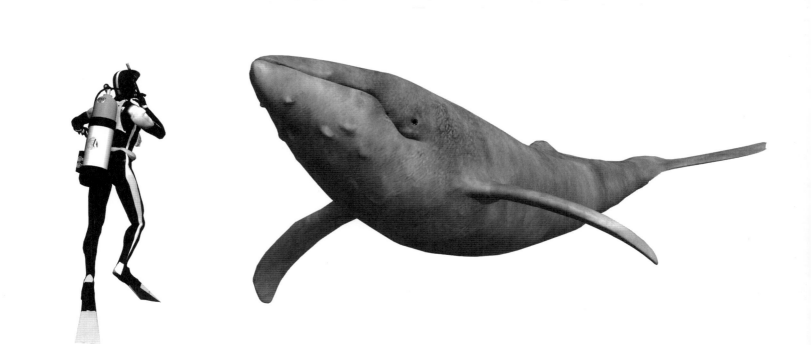

NEED MORE BLANKS?

Visit quirkbooks.com/fillintheblank to:

☐ **Download exclusive new images**

☐ **Share your finished illustrations with others**

☐ **Join the conversation and much more**